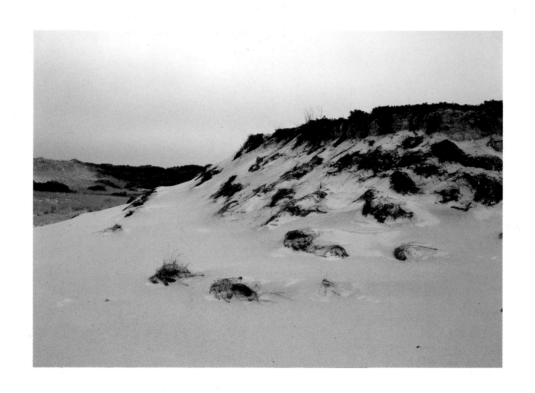

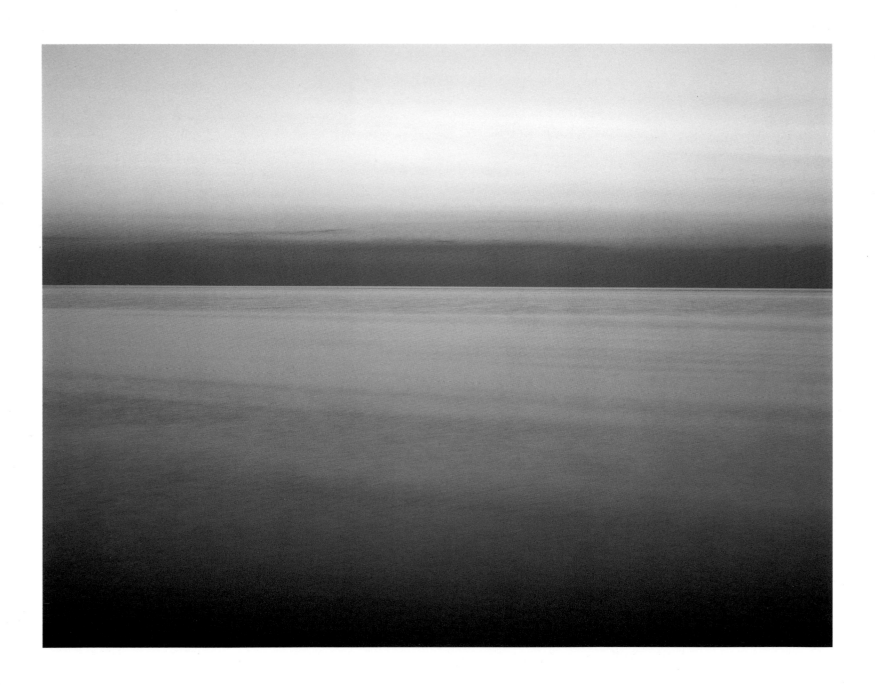

Cape Cod

Visions of a Landscape

Photographs and text by Brian Robert Smestad

Introduction by Brian Cassie

DETAIL PRESS

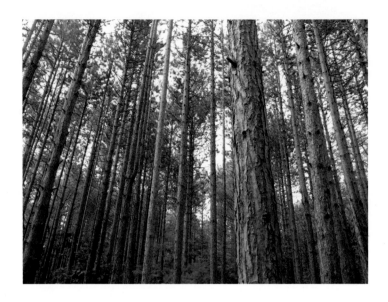

Library of Congress Cataloging-in-Publication Data

Smestad, Brian R. 1979-
Cape Cod Visions of a Landscape / Brian Robert Smestad

First edition
10 9 8 7 6 5 4 3 2 1

Introduction by Brian Cassie

Designed by Brian Robert Smestad
Printed in Korea through Bolton Associates, San Rafael, California
Set in Garamond

Includes index
ISBN 0-9711321-0-0
LCCN 2001117761
1. Photography, Artistic. 1. Travel Photography. 1. Title.

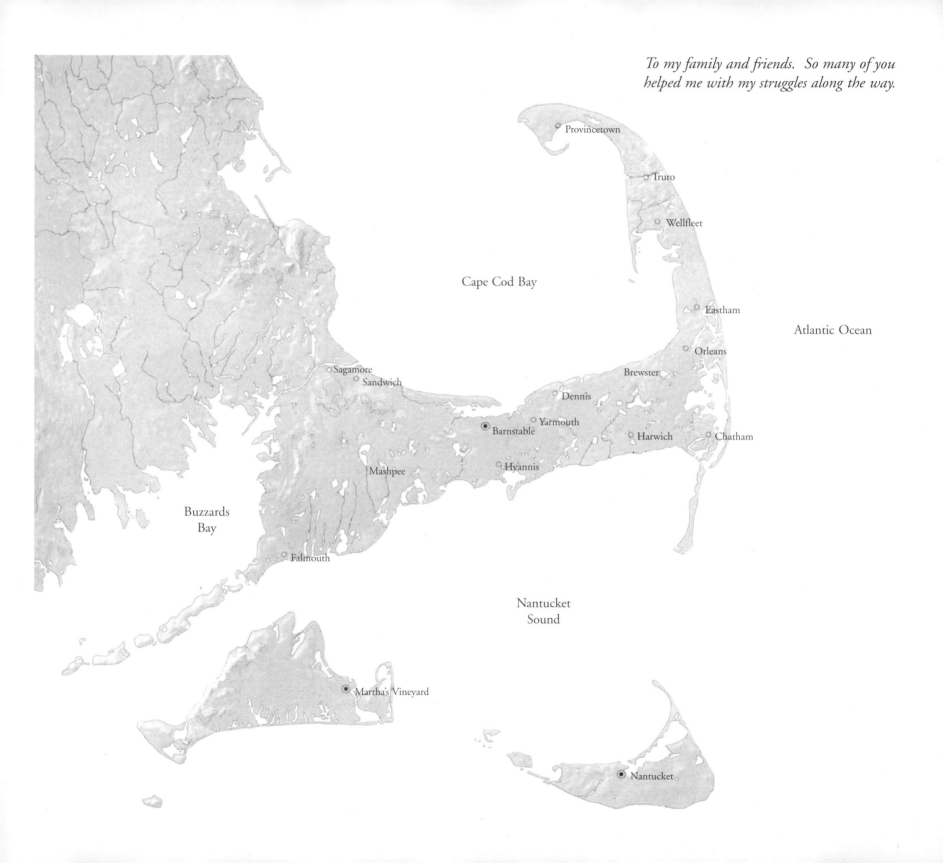

To my family and friends. So many of you helped me with my struggles along the way.

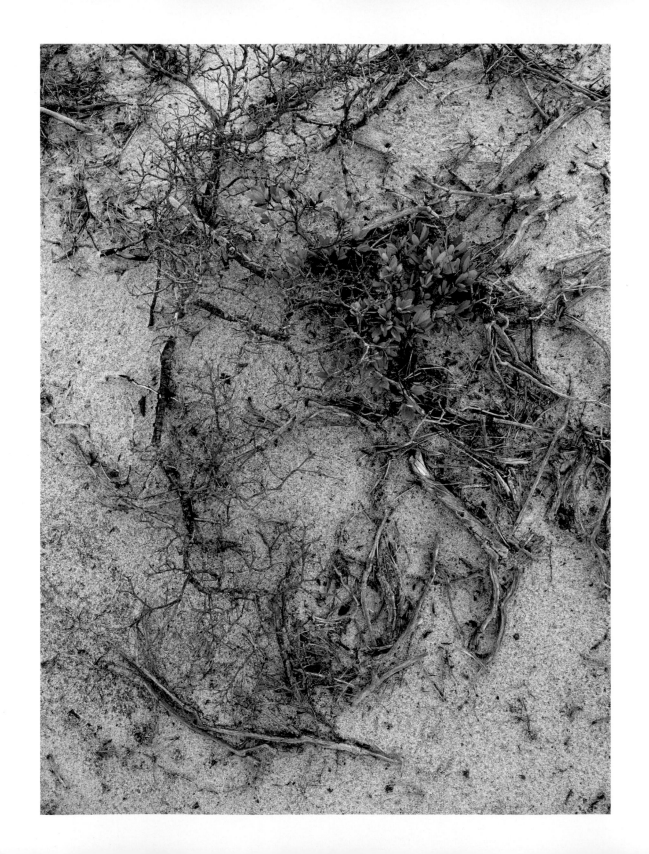

Introduction

Thirty years ago, just at the start of my first year in college, my family moved to Orleans, at the elbow of Cape Cod. I had spent most of my life up to then near the ocean and, in fact, had the ocean for a backyard from seventh grade through high school. But I grew up on a crowded peninsula on Boston's south shore and my parents thought it was time for a change to a more rural setting. Orleans was their choice.

I wasn't there when we moved to the cape but was off pursuing whatever freshmen pursue in their first fall of campus life. Maybe that's how I got mononucleosis—a really good case that sent me home to recuperate for eight weeks. Eight weeks is a long time for an 18-year-old athlete to be housebound and I still thank Sue Kinnear, my high school sweetie, for bringing me something to help get me through. Sue gave me a bird field guide, the first bird book I ever owned. That book opened my eyes.

Cape Cod is an outstanding place to watch birds. Even its backyards are good, as I discovered on Rock Harbor Road. There were radiant evening grosbeaks by the dozens (though they are mostly gone now), comical flickers, and even an eastern screech-owl perched on the porch railing early one morning. I was sick, but life was good and getting better, thanks to Sue's present.

I did not settle on Cape Cod but have returned hundreds of times in the years since my college days, often to look for birds. Down Monomoy, up to Provincetown's Beech Forest, over to the dunes at Sandy Neck, Barnstable, watching seabirds and plovers and sparrows through the seasons. But these days, most often I find myself not in hot pursuit of a peregrine falcon or a marbled godwit but just out on a beach, walking along, maybe even without binoculars, savoring the ocean and my presence on the cape.

Beaches are the essence of Cape Cod at any season, but for the naturalist and photographer the cape beaches are at their best from fall to spring, when the summer noise has departed. Then, a person can be alone with the sand and wind, the birds and shells. The dunes at Cahoon Hollow are most splendid in the fall, their multihued sands as spectacular as the autumn foliage. Morris Island and South Beach in Chatham, where black and white fossil shells from the last Ice Age litter the shoreline

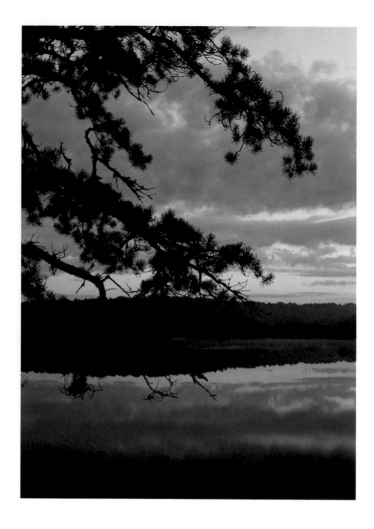

and where the once-rare Gray Seal is now a common sight, are resting places for great droves of southbound shorebirds. On the bay side, Eastham's First Encounter Beach, where the Pilgrims made their first landing, spreads to the horizon at lowest tide. The razor clams and hermit crabs are abundant here, as is the elbow room. Not so many people walk out on the exposed flats, here or anywhere else in the world. What they are missing.

Winter is the perfect time for the outer beaches of Nauset, Coast Guard, Marconi, and Race Point. There is solitude. There are whales. There are crashing, thundering breakers in the wake of a nor'easter, and all sorts of marvelous flotsam and jetsam littering the beaches following that same storm—delicate black egg cases from little skates, huge apple-sized moon snails stranded at the high tide line, too many sorts of seaweed to fathom. Not far offshore, northern gannets are a familiar sight here all through the cold weather months. To watch their expansive, brilliantly white forms fold up and plummet headfirst into the Atlantic is to experience one of the marvels of this long, long arm that juts so far out into the sea.

Springtime on the beaches brings the return of the cape's terns and plovers. At Popponesset Beach, they fuss over any intruder who strolls near their nesting grounds—the terns can draw blood from the scalp of someone who is too inquisitive. Beautiful mother-of-pearl pandora shells and scallops, often brilliantly colored in their first few months of life, find refuge in the eelgrass beds, and other unnamed tiny shells by the thousands wash

up in countless dimples in the sand. A minus tide on the spring beaches calls to the naturalist and beach comber, "Come explore me."

I have never been on Cape Cod with my neighbor and friend Brian Robert Smestad. Still, I can tell from his photographs of the beaches and woodlands of the cape that Brian sees its glorious landscapes through the eyes of a lover of his trade. He plies the countryside at dawn and at sunset when the light is most radiant and intriguing, and gives us memorable shots of memorable vistas, from Woodneck Beach to Nauset. The intricate mosaics of granite cobble, the drenching greenness of an Atlantic Cedar Swamp, and especially the long, arching sweeps of the cape beaches are all beautifully caught by the eye of one of the finest young photographers anywhere. The cape has had its share of honored photographic chronicleers over the years. We can now add Brian Robert Smestad's name to the list.

—Brian Cassie
Naturalist

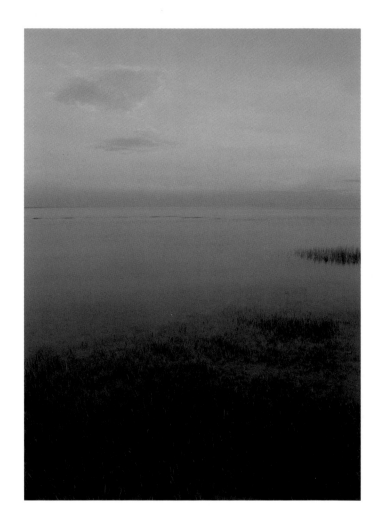

The beach offers solitude.

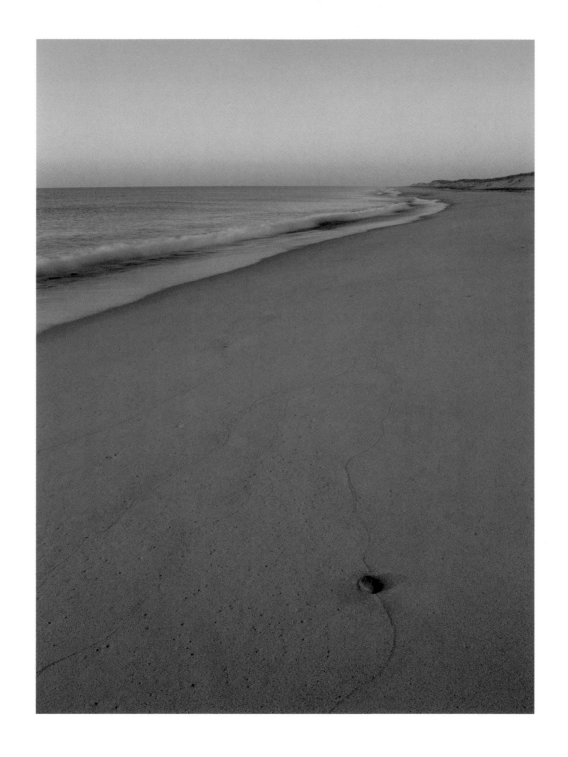

The palette of light changes before your eyes.

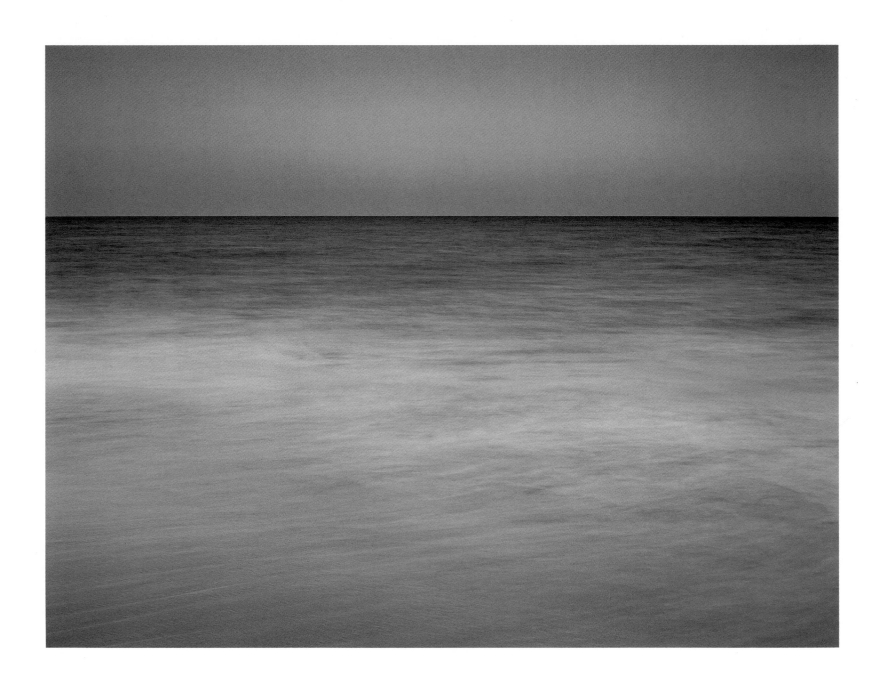

Moving currents sweep away all that isn't holding on.

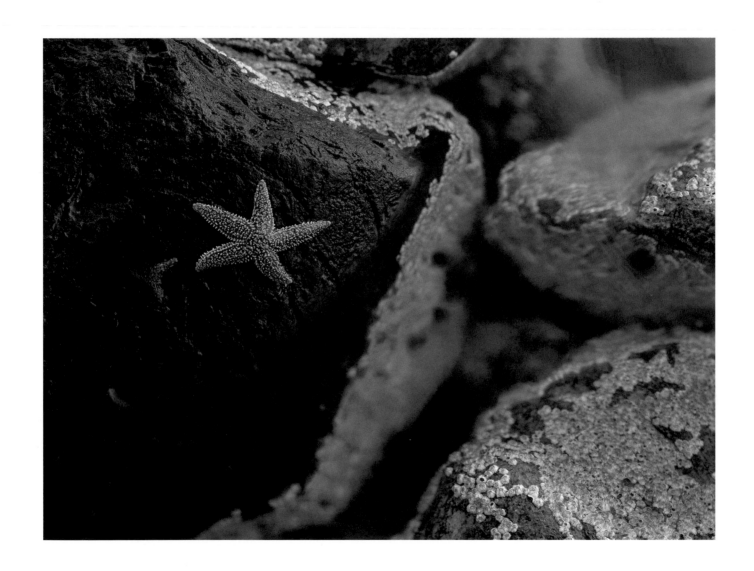

Low tide leaves intricate details waiting to be discovered.

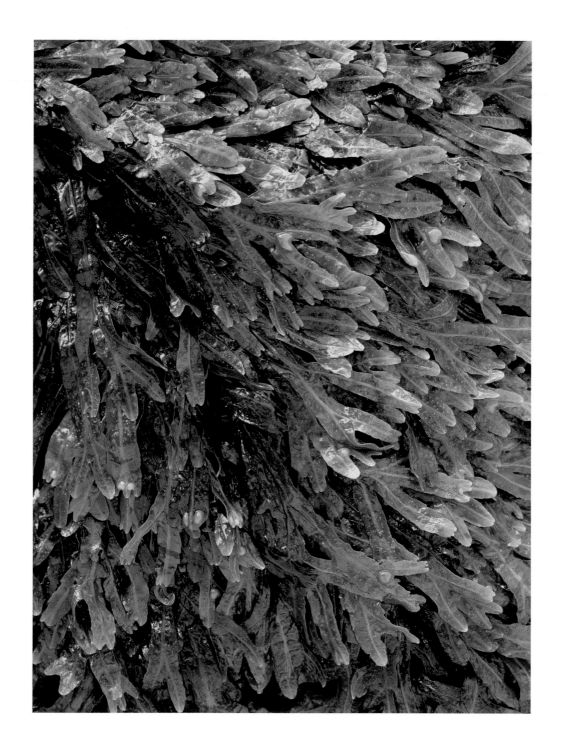

Warm sun, cool air, a beautiful Saturday morning.

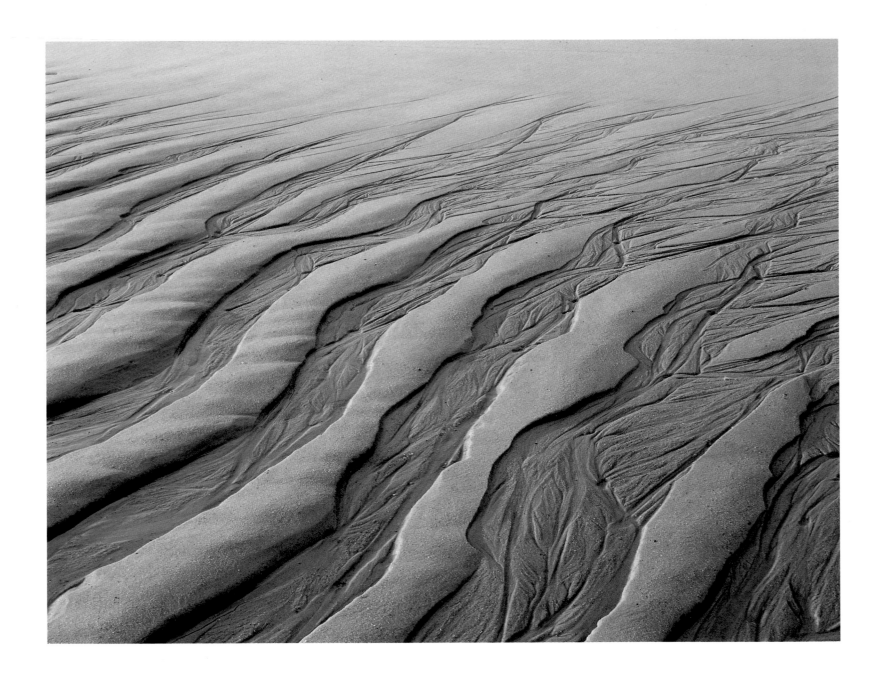

Beyond miles and miles of dancing beach grass, the Atlantic forces its way in.

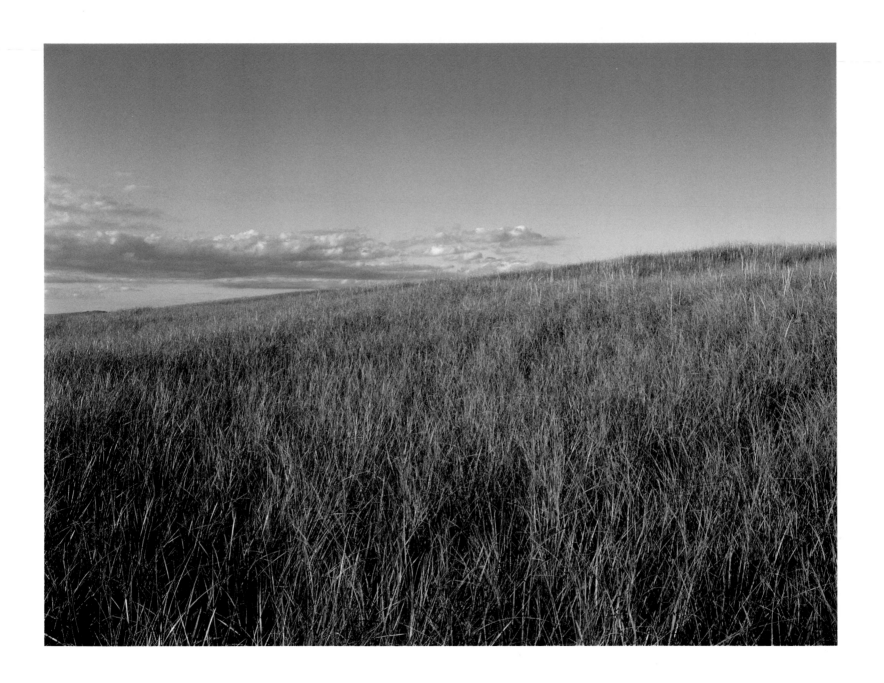

A torrid afternoon in the blazing sun.

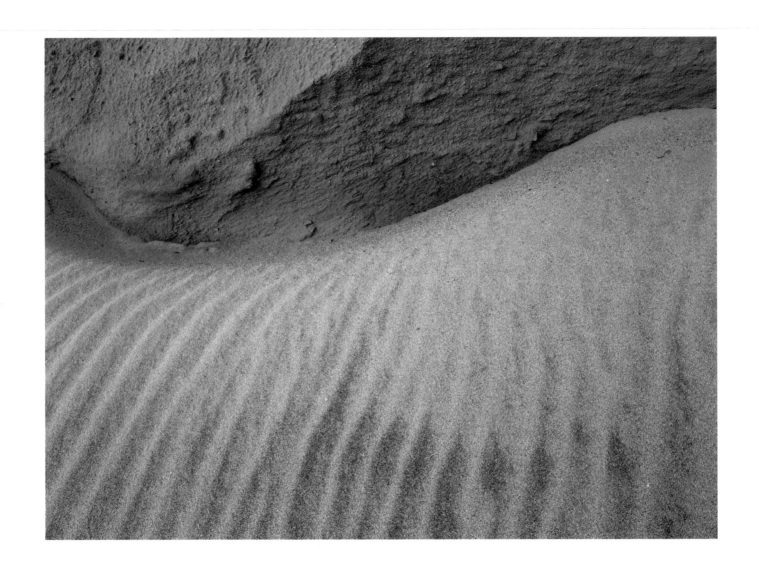

A barefoot walk with the warm sand caressing your soles.

It's another windless evening.

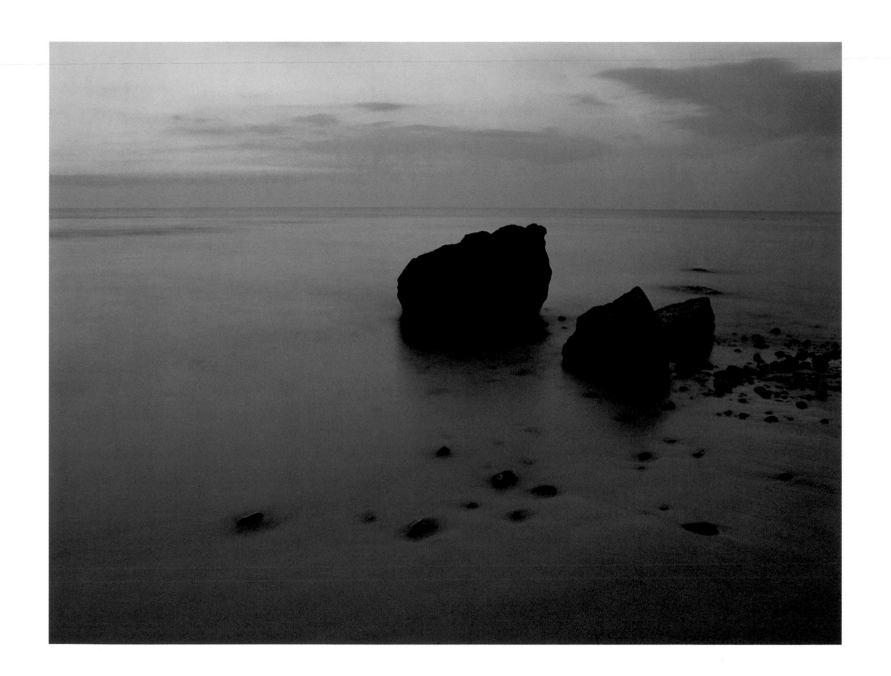

Seagulls hovering above sand covered feet, June.

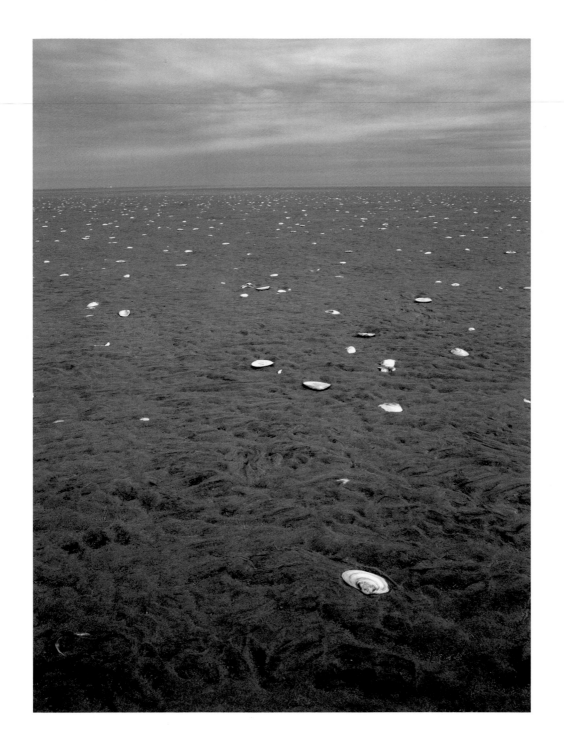

Rain rolls off leaves and drops to the ferns beneath.

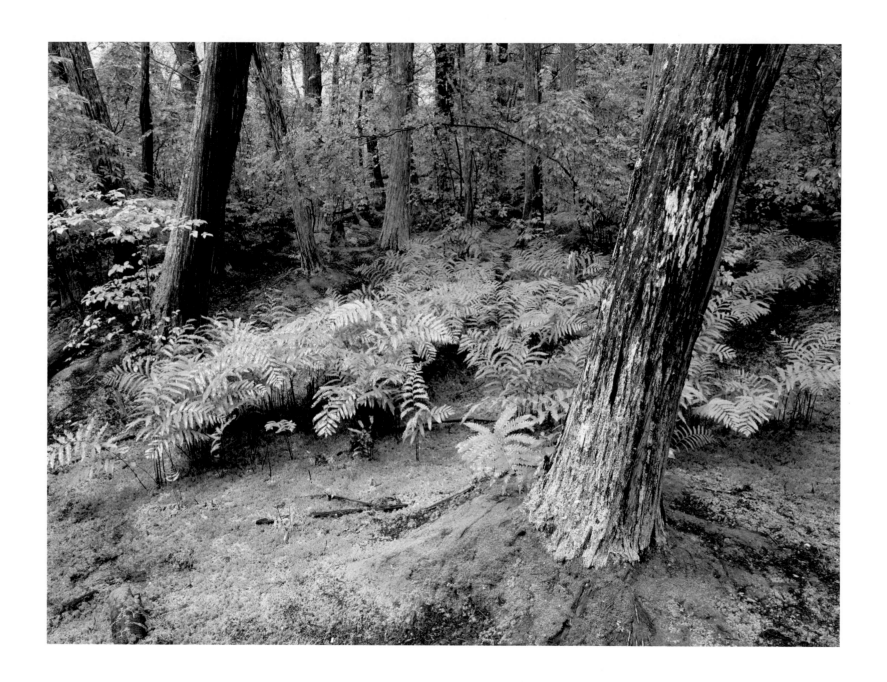

A full moon illuminates the frozen reflections of pines.

An unforgiving mist extends from the sea.

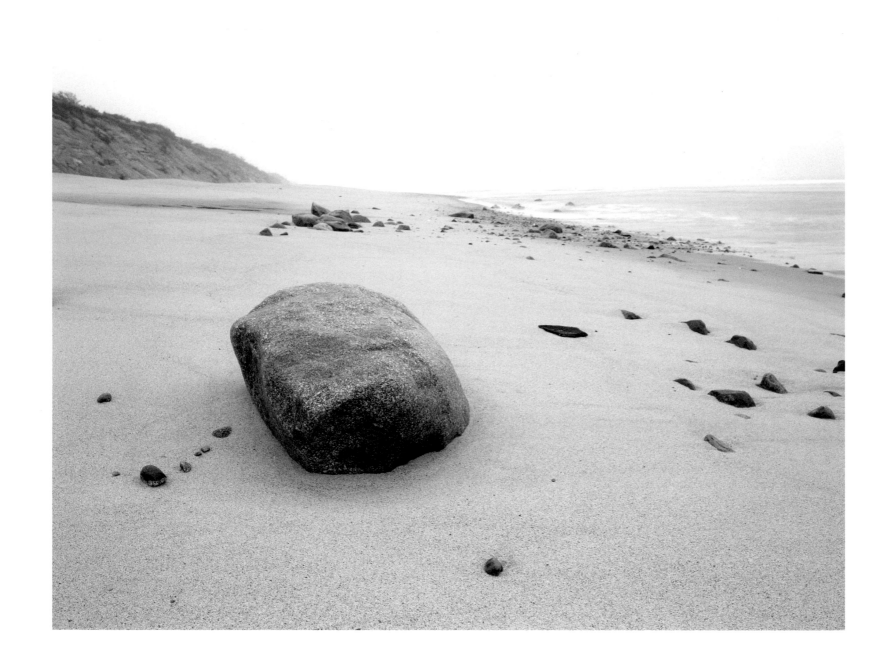

33

Feet anchored in the sand.

Chilled water moves in from a passing nor'easter.

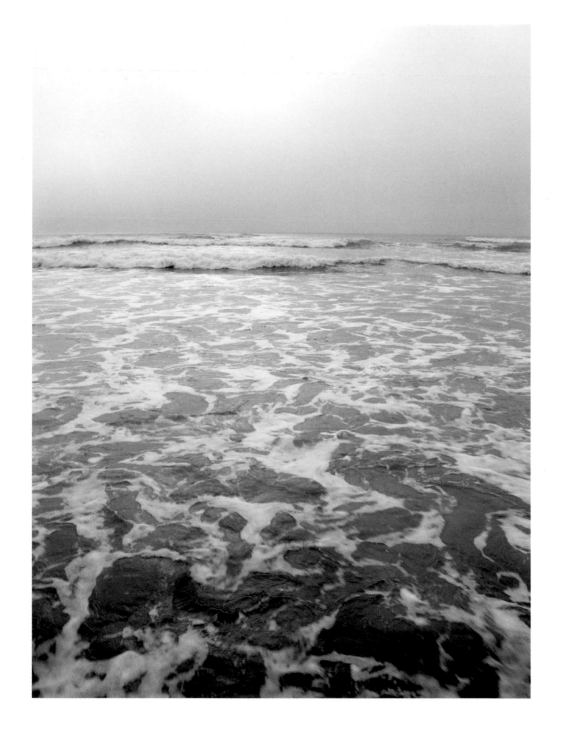

A gloomy day over lichen-splattered rock.

Morning. The faint sound of crashing waves.

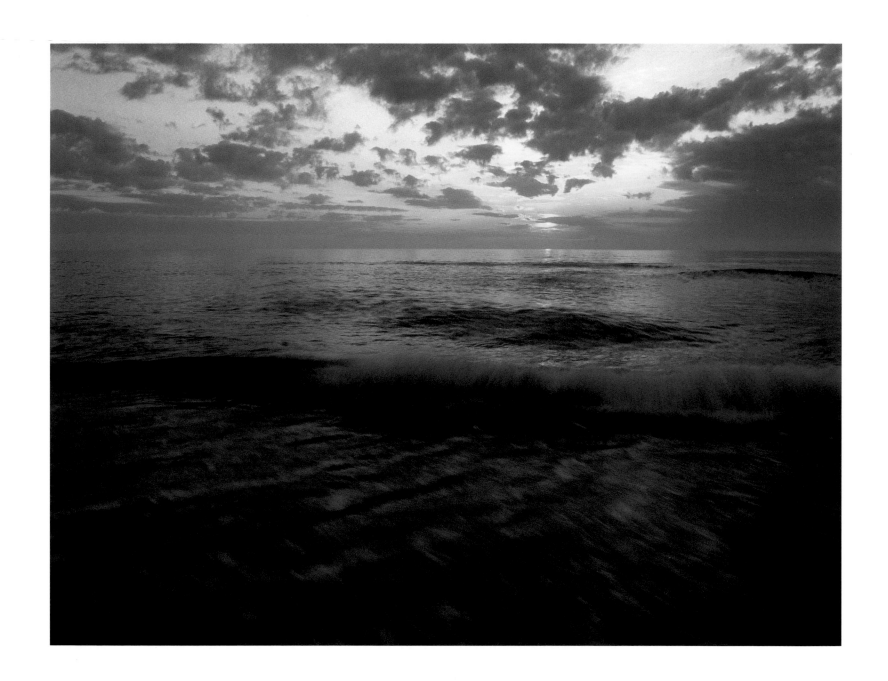

An ongoing battle between land and sea.

What is left today will be gone tomorrow.

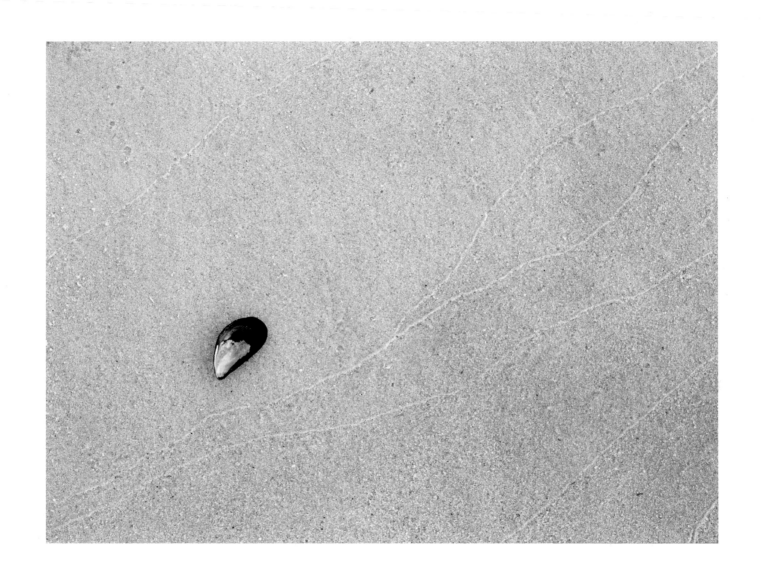

Long walks below a canopy of changing skies.

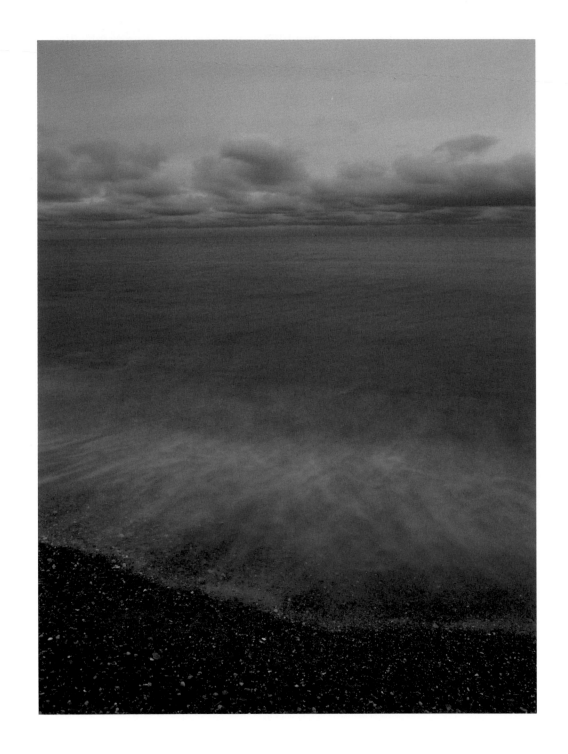

Dampered by the sand dune amphitheater, tiny roots anchor in a sea of sand.

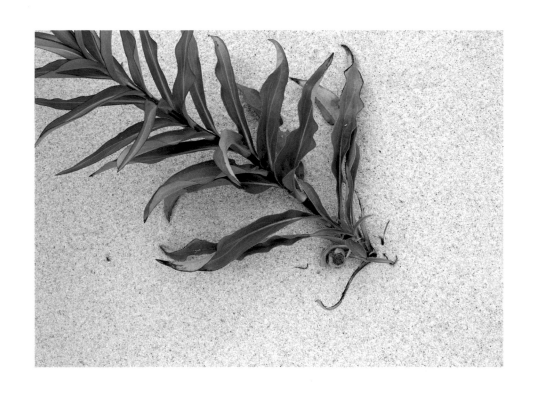

Green leaves twirl as a crisp sea breeze weaves through the Mashpee forest.

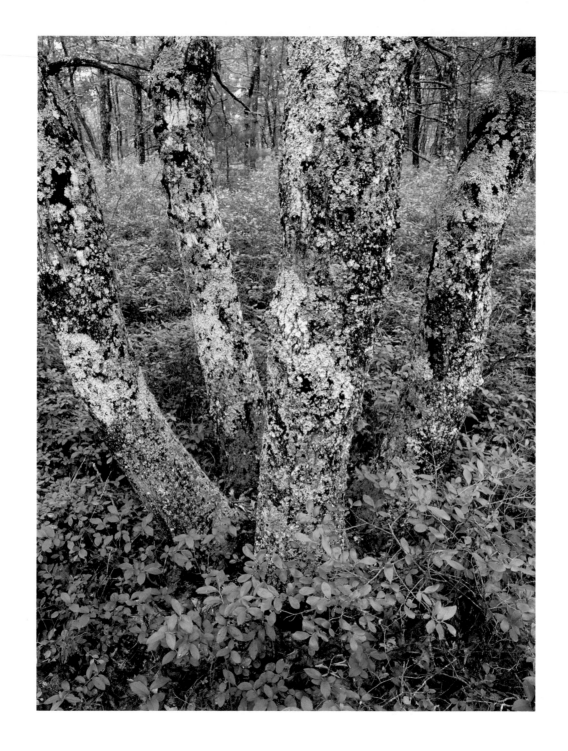

An eerie afternoon with fog devouring all in its path.

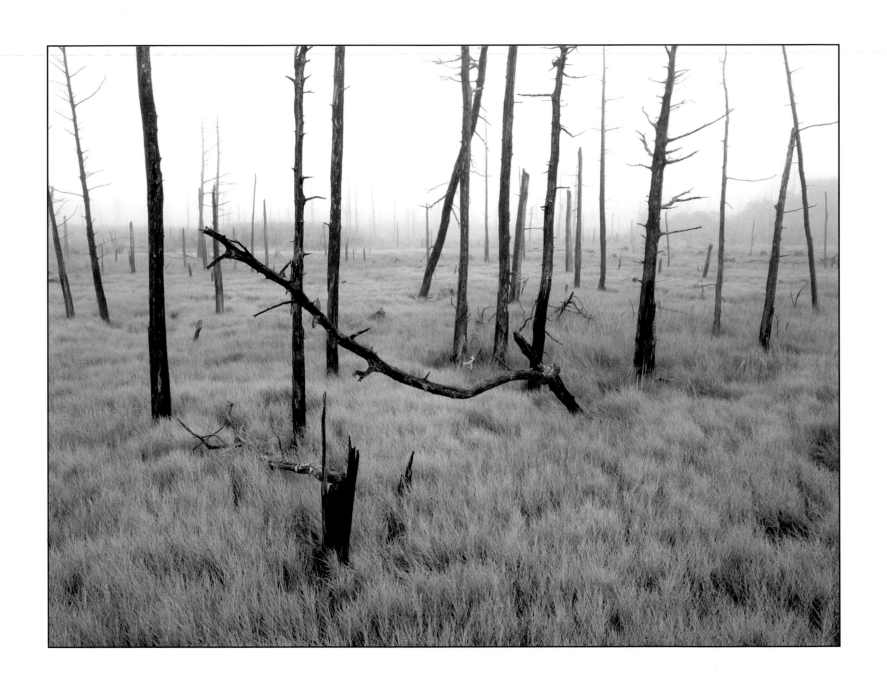

Mysterious ventures along the shore.

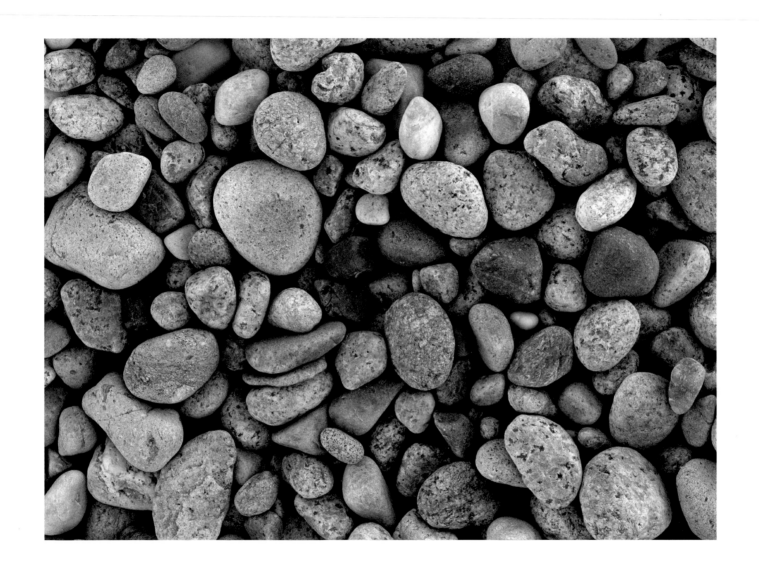

Pebbles tumble back and forth. Another wave retreats.

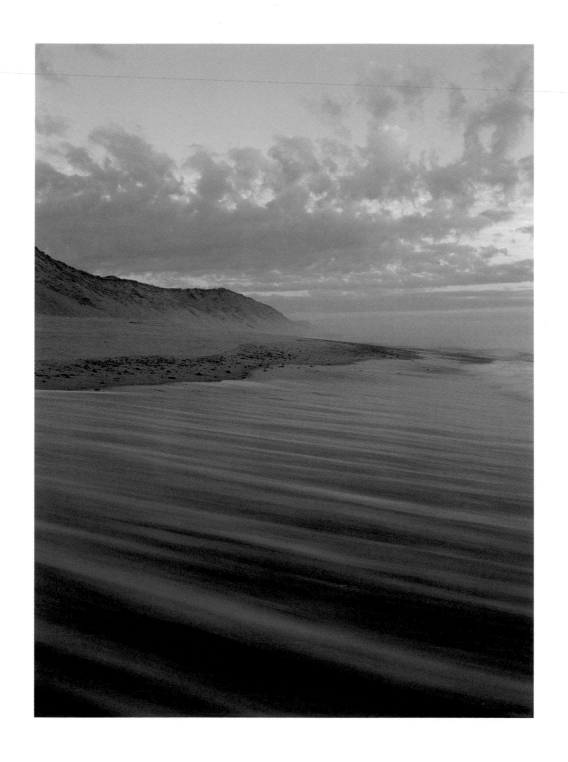

Feeble currents ... 8:42 p.m.

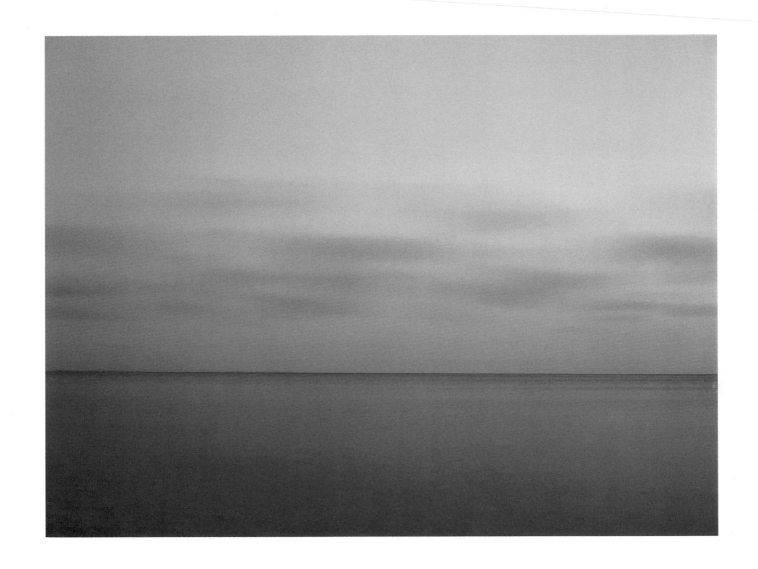

Beyond paved roads.

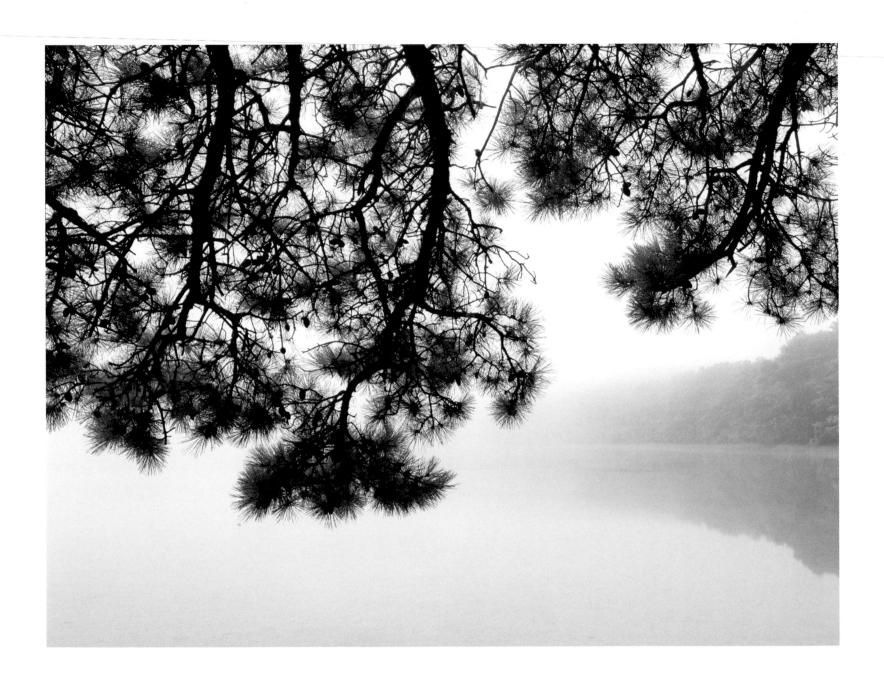

A single bullfrog adjusts to your presence.

Within minutes, a full chorus sings from every direction.

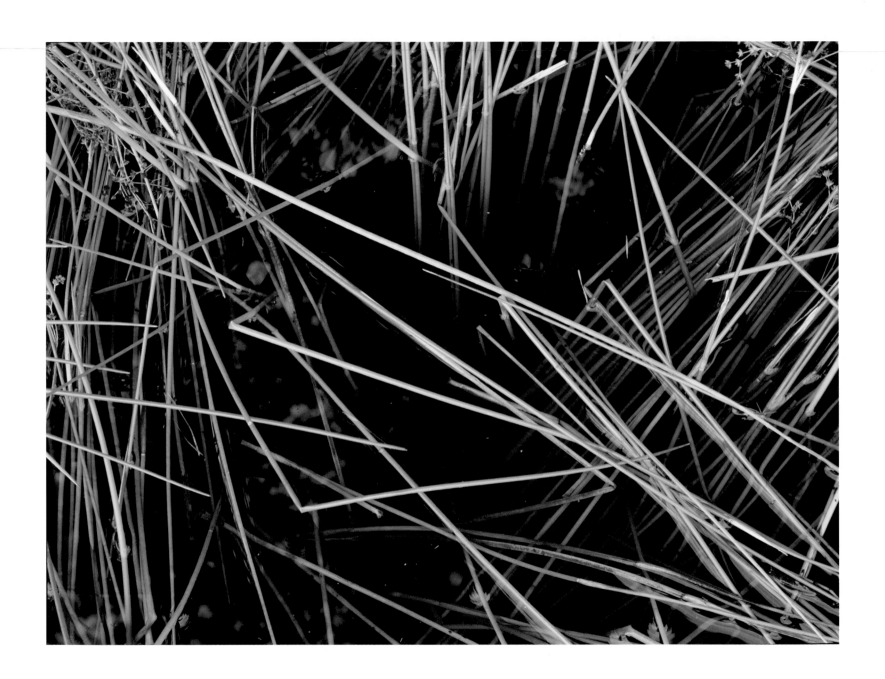

Eventide.

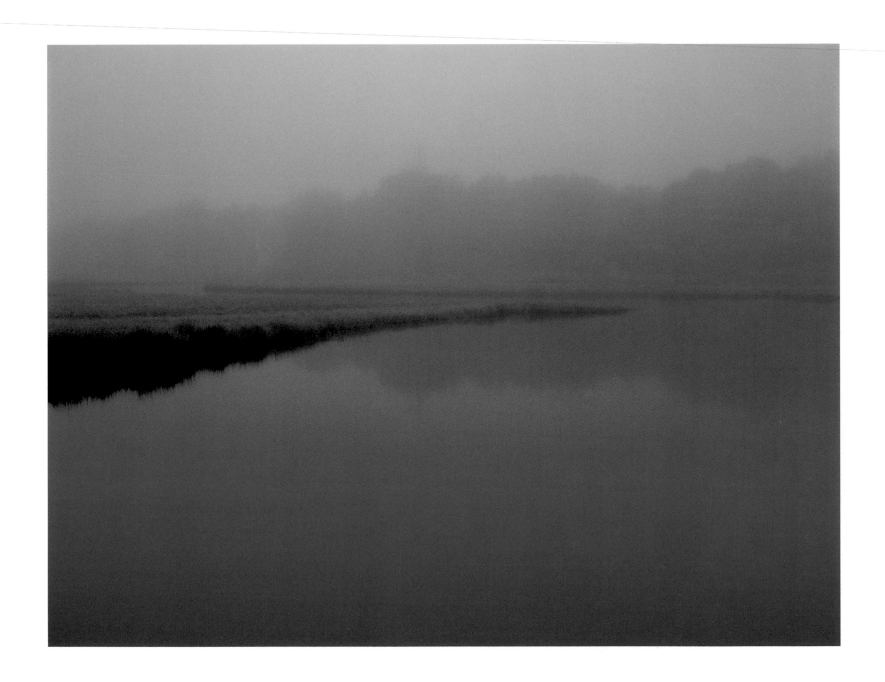

Another overcast day.

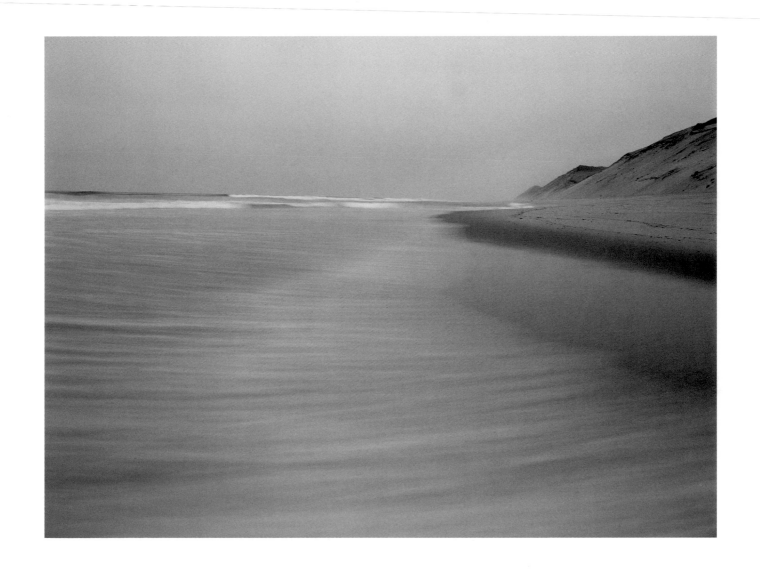

A small stroll before it showers.

Late afternoon.

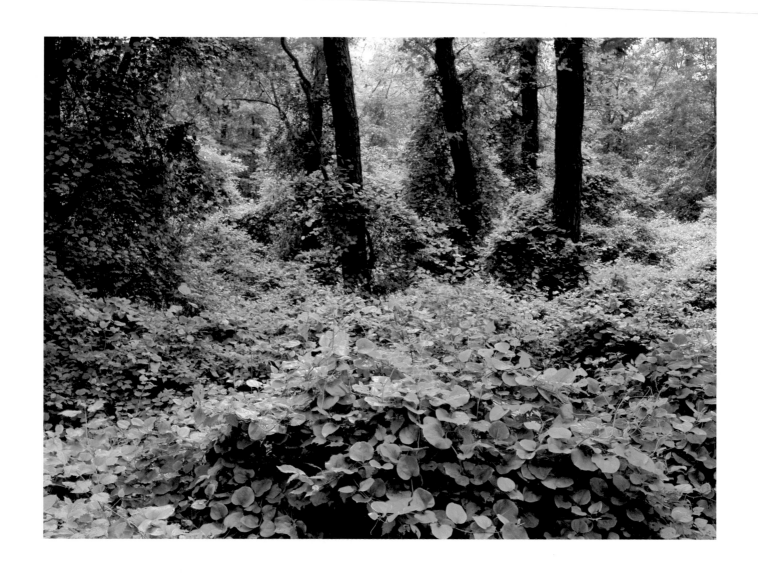

September.

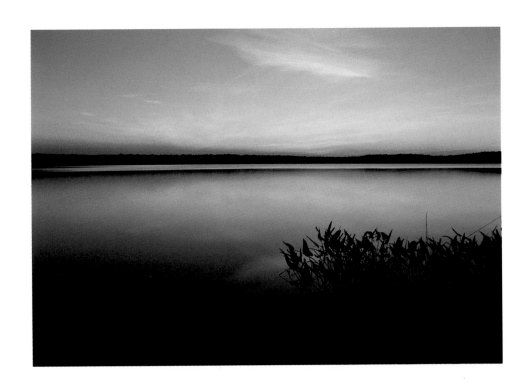

The tide creeps in.

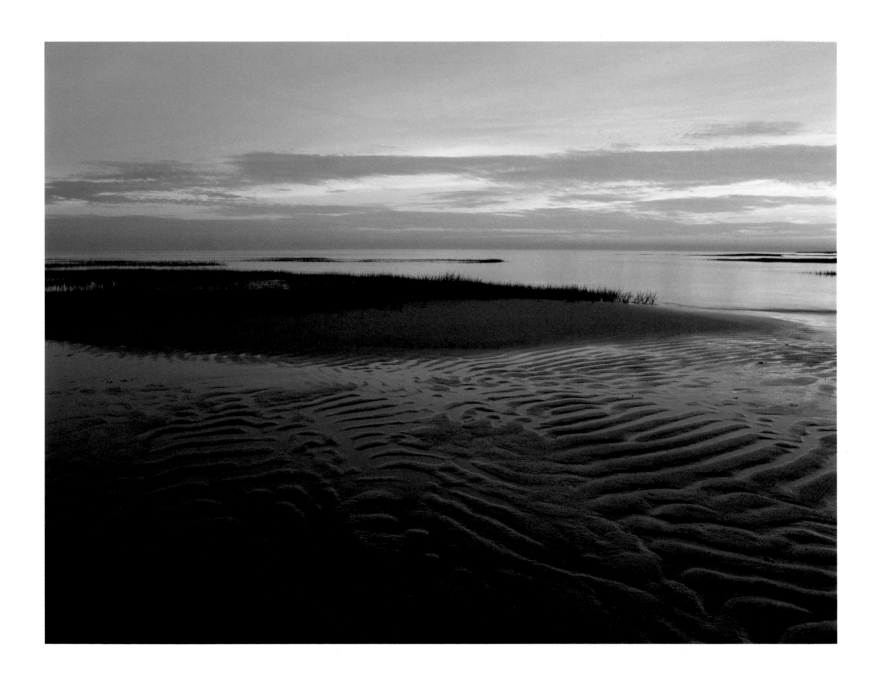

Lurking below, tiny softshell crabs wait for their next meal.

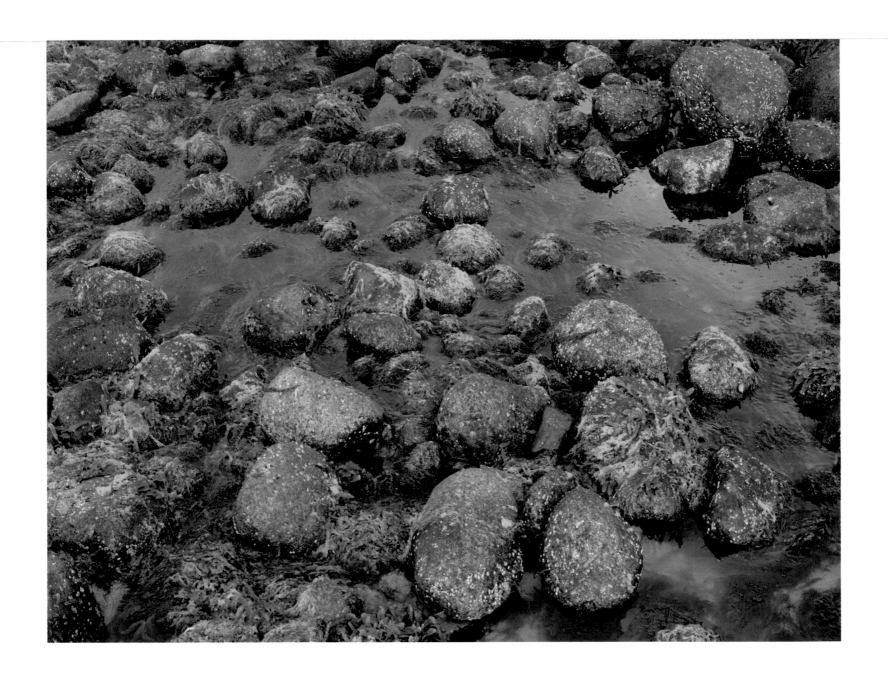

A tremendous wind collides with massive dunes.

Forcing individual grains of sand further and further inland.

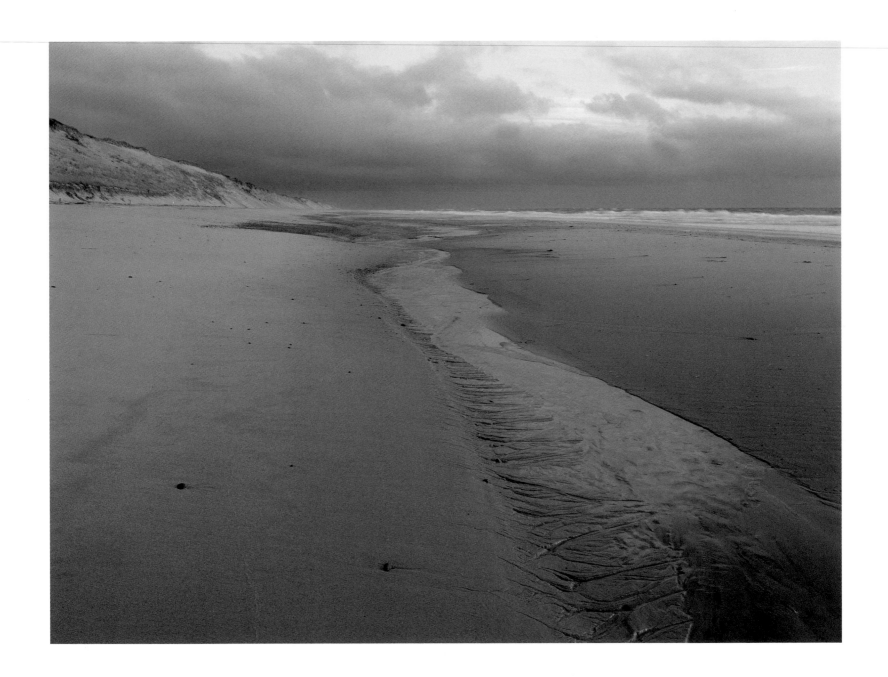

Grass waltzes in the whistling wind.

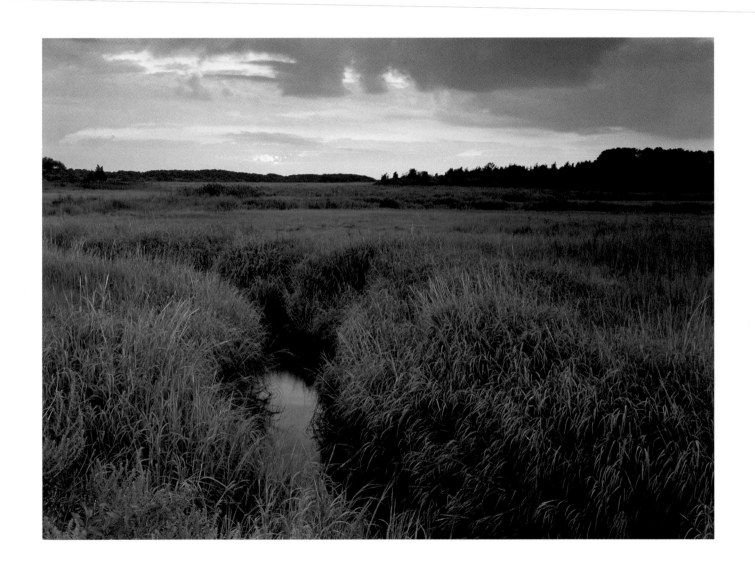

Grabbing at the land to pull itself in, the tide reaches the furthest point only to release its massive hold.

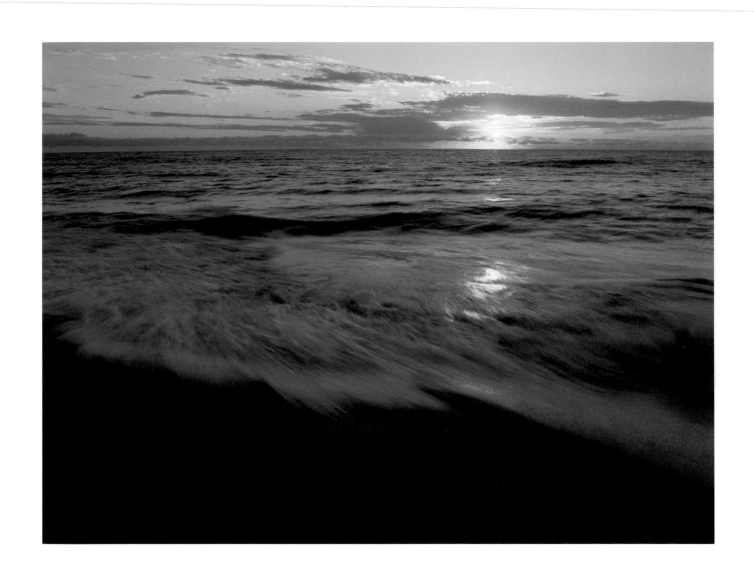

Coarse sand creeps down a dune.

Each gust of wind pushes it in other directions.

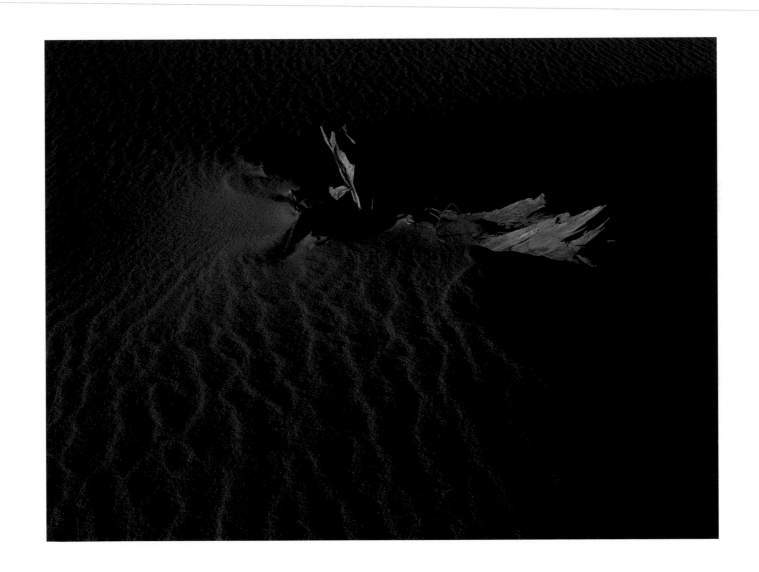

Warm salt air clings to your skin.

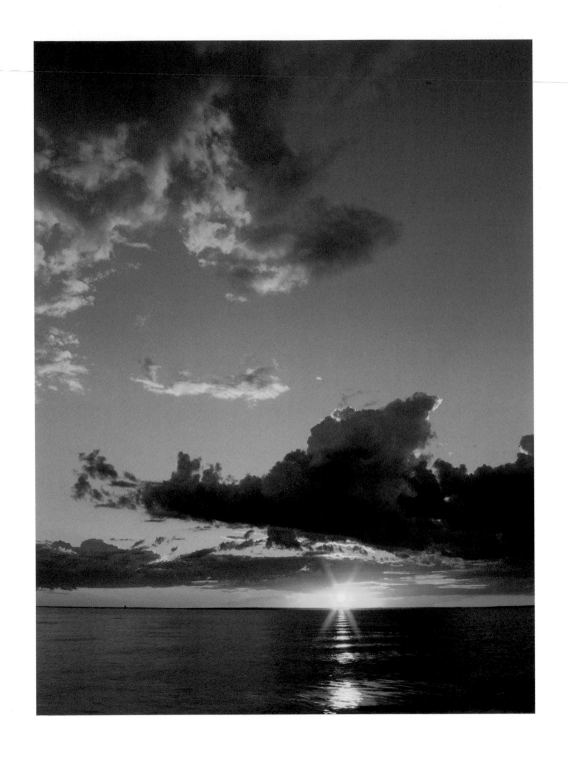

Summer's end.

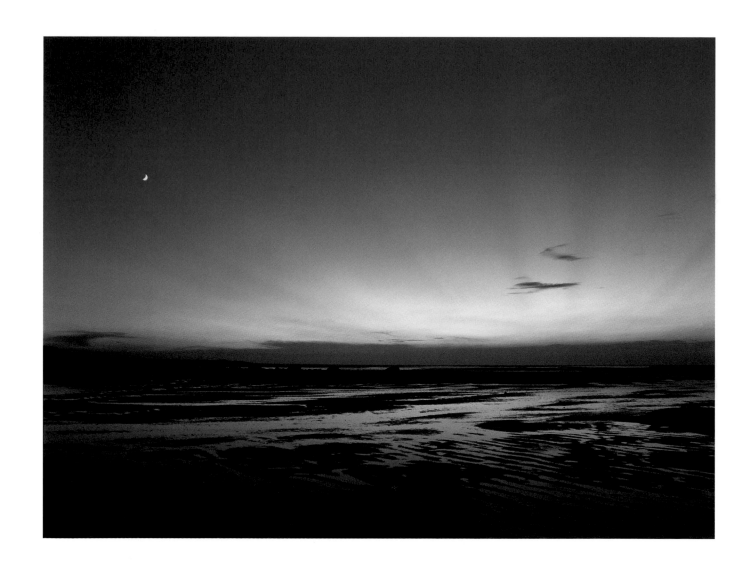

Acknowledgments

First and foremost, I would like to thank Monica Sweere for putting up the required funds for the printing of this book. Seven months ago, by chance, we met outside one evening at a cafe in Fort Collins, Colorado. After she asked what I was working on, we had a long conversation about art and photography. Before I knew it, we were meeting in a week to view my work. From that point on, she has been extremely helpful in making my vision a reality.

I'm also thankful for the support of my entire family. I know it has been difficult to understand the paths that I wander, but nevertheless, you all have been there for me.

Throughout the summer I called Galen Saturley (Shrub) in Colorado. Usually it was at random times in the night and we would discuss the little dilemmas with this project. Along with being an incredible friend, he has helped with the editing of the photographs.

I would like to thank Joanne Bolton, of Bolton Associates. With her immense knowledge of the print world, as well as her patience, she has helped out in the final steps of this project.

The following people have contributed in many ways throughout the making of this book: Brian Cassie (he wrote the introduction on such short notice); Gerards Photo Lab, Ft. Collins, CO; Kevin S. Yamashita; Dave Santillanes (he dealt with the color corrections of all the images); Marcia De Moss; Spectrum Lab, Boston, MA; Photo Craft, Boulder, CO; Bergen R. Ekland; Margaret and Billy Hollander; Eric and Denyce Rusch; Adrian R. Davis (Stickboy); Mike Goshorn; Chris Sullivan; Kristin Nason; Nicole and Andrew Carleton; Timothy Brister; Steve Golgart; Joel Rea; Stacey Cutliff; Janelle Browning; Dave Williams; Sean Haworth; and finally Carol Rehme (she spent a great deal of time helping me improve my writing).

April 2001 *BRS*

About the photographs

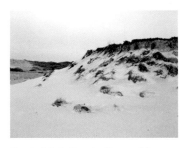

Sandy Neck Beach, Barnstable;
p. 1
After three weeks of overcast skies, I lost my desire to photograph. Then I had many conversations about art and photography with my good friend Galen Saturley who, in the end, encouraged me to go out and shoot.
1/4 second at f22
41 44.312 - 70 22.781

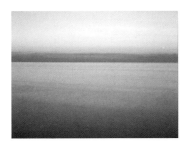

Ellis Landing Beach, Brewster;
p. 2
On the bay side of the cape, the tide can go out two miles. One evening, I was walking on the tidal flats trying to reach the edge of the water for sunset. A mile away from shore the tide swept in and submerged my ankles, then my knees. Soon I was waist deep in water with all of my camera equipment. After taking a few exposures, I carried my camera over my head and trudged back to dry land.
15 seconds at f22
41 46.571 - 70 03.354

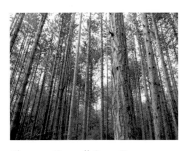

Shawme Crowell State Forest, Sandwich; Red Pine; *Pinus resinosa*
p. 4
Often, I woke before sunrise and drove aimlessly.
1 second at f22
41 44.967 - 70 30.535

Cape Cod National Seashore, Provincetown;
p. 6
In the first week of living and photographing on Cape Cod, I planned everything. This meant analyzing topo maps, tide charts, weather reports—anything that would contribute to a better photograph. When Spectrum Lab in Boston developed my film, there were similarities in each frame. They all seemed planned. To me, a visually contrived photograph lacks a connection between emotions and inspiration. After that, I focused my attention only on the parts of the cape I would photograph.
10 seconds at f22
42 04.581 - 70 12.563

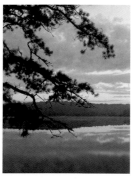

Great Pond, Wellfleet;
p. 8
The entire summer I read stories about mosquitoes carrying the West Niles virus. Ambushed by a fleet of mosquitoes, I made several uncomfortable attempts at this shot.
10 seconds at f22
41 56.282 - 69 59.985

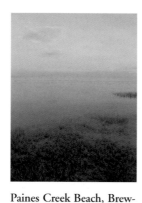

Paines Creek Beach, Brewster; Saltmarsh Cordgrass;
Spartina alterniflora;
p. 9
Two years ago, I made a day trip to this beach with my friend Chris Sullivan. I was fascinated by the flats, which held little patches of grass and tidal pools. There were so many things to explore. I stood for fifteen minutes and watched the water come in, amazed at the beauty of the moment. That was my inspiration to create a book about Cape Cod.
1/2 second at f22
42 45.726 - 70 06.783

Nauset Beach, Orleans;
p. 11
Usually in the morning if you walk a little further than the entrance to the beach, you won't find footprints. Arriving at an empty parking lot, excited for a beautiful sunrise, I strolled the shore line. As I set up, the inevitable jogger came into my compostion. As soon as she faded in the distance, I released the shutter.
1/2 second at f22
41 46.973 - 69 56.069

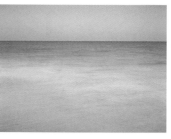

Seagull Beach, Yarmouth;
p. 13
For a long while, I was uncertain how I wanted this project to end. I spent a lot of time sitting on the edges of the shore thinking.
1/4 second at f22
41 37.966 - 70 14.057

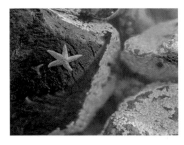

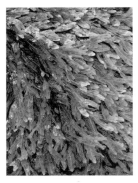

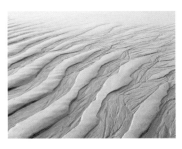

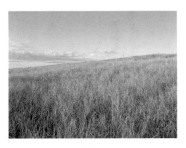

Nauset Harbor, Orleans;
Forbes' Common Sea Star;
Asterias forbesi;
p. 15
I made trips to Spectrum Lab almost once a week to get my film processed. At the time, I drove a white 1984 Toyota van which lasted throughout this project. Tired from the previous day, I left the box with the rolled-up film on the roof of my car. Twenty minutes later, I rushed back to the parking lot feeling fortunate to find the box flattened, but not crushed. All of the frames had been destroyed but this one—the only one I had intended to use.
1 second at f22
41 48.609 - 69 57.128

Sagamore Beach, Bourne;
Bladder Rockweed;
Fucus vesiculosus;
p. 17
The rising tide left me little time to photograph a section of this bladder rockweed.
2 seconds at f22
41 48.377 - 70 32.024

Chatham;
p. 19
On certain beaches there are prime spots where fishermen start their days early. After I explored the beach for a while, I found myself trying to force an image and, disgusted, quit for the day. As I walked back to my car, a curious fisherman called out to me. We talked briefly about cameras and photography and soon I was off. If I had not walked over to him, or if he had not been interested in what I was doing, I never would have seen this section of sand cut away by the receding tide.
1/4 second at f22
41 39.910 - 69 56.675

Nauset Beach, Orleans;
American Beach Grass;
Ammophila breviligulata
p. 21
Nauset Beach extended forever. I walked south, near the edge of the ocean, and ended up on the back-side of these dunes. By the time I headed back to the car, the sun was setting and I was still hours away, walking in loose sand with no insect repellent. After a few miles of flinging my arms around in an attempt to repel the mosquitoes, I hitched a ride in the back of a couple's pickup.
1/8 second at f22
41 44.552 - 69 55.827

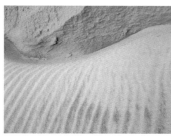

Great Island, Wellfleet;
p. 23
The temperature was so high the day
I photographed this section of a dune
that I went for a swim afterwards.
6 seconds at f22
41 54.437 - 70 04.290

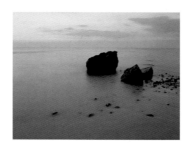

Woodneck Beach, Falmouth;
p. 25
I frequented this beach, strewn with
massive boulders left by glaciers, to
witness the sun fall below the earth.
Watching each wave come in and
then go out became a peaceful
rhythm that I enjoyed.
45 seconds at f22
41 34.494 - 70 38.508

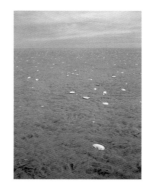

**Paines Creek Beach,
Brewster;
Atlantic Surf Clam;**
Spisula solidissima
p. 27
I walked and walked but
never reached the water's
edge. Before I turned to go
back, I came upon these
shells.
1/8 second at f22
41 46.316 - 70 07.009

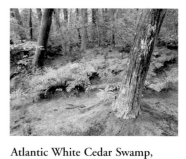

**Atlantic White Cedar Swamp,
Wellfleet;
Atlantic White Cedar;**
Chamaecyparis thyoides
p. 29
Having never ventured to this swamp
before, I set out with plastic bags, a
gortex jacket, waders, and an enor-
mous blue and white beach umbrella
modified to keep the camera equip-
ment dry. Three hours later—and
soaking wet—I came to terms with
myself.
10 seconds at f22
41 54.686 - 69 58.876

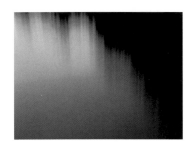

Fresh Pond, Dennis;
p. 31
Mike Goshorn and I conversed about how the daily complications in life are suspended—or at least lessened—while we're out photographing. The lens lets us focus on the moment.
1 minute at f22
41 40.578 - 70 08.973

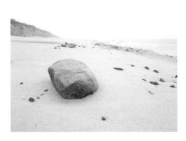

Coast Guard Beach, Eastham;
p. 33
I spent a long time in this setting. Several weeks before, there were many disappointing attempts to photograph the cape from the vision that was conjured in my mind. I realized my passion for Cape Cod had grown stronger with each day spent wandering its beaches. In the end it resulted in images that were more in tune with my initial vision.
2 seconds at f22
41 51.039 - 69 56.890

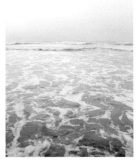

Coast Guard Beach, Eastham;
p. 35
Standing ankle deep in the water to compose this shot was extremely painful. I lost all feeling in my feet and when each wave came in higher, it reminded me how cold it was after a nor'easter.
1/30 second at f11
41 51.033 - 69 56.887

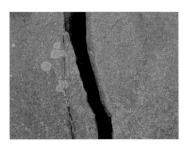

Nauset Harbor, Orleans;
p. 37
During this exposure, I had to pace up and down the trail because the "noseeums" were incredibly forceful.
6 seconds at f22
41 48.516 - 69 57.181

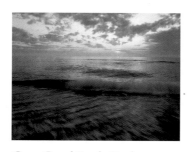

Coast Guard Beach, Eastham;
p. 39
It normally takes me a long time to compose. However, there were numerous occasions where I would spend little time composing yet still take the shot. Without a connection between my subject and me, the impact was always lost.
4 seconds at f22
41 50.711 - 69 56.789

Craigeville Beach, Barnstable;
Edible Mussel; *Mytilus edulis*
p. 41
Photographing with Mike Goshorn is always a pleasure. Click...Click... and he releases the shutter again. Twenty feet from him, I fight my tripod and swear profusely at it. Mike turns to me and says, "It's so peaceful out here."
1/4 second at f22
41 37.657 - 70 18.659

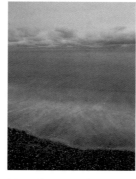

Menauhant Beach,
Falmouth;
p. 43
One idea behind this book was to show the cape without human touch. We come here for its beauty, so it's important to remind ourselves that Cape Cod is environmentally at risk.
12 seconds at f22
41 32.981 - 70 33.239

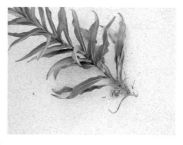

Sandy Neck Beach, Barnstable;
p. 45
After a cup of coffee from Woolfies Bakery in Dennis Port, I headed to Sandy Neck. Amidst the dunes, surrounded by dancing beach grass, and fascinated by roots buried in sand, I photographed this.
1/2 second at f22
41 44.203 - 70 22.132

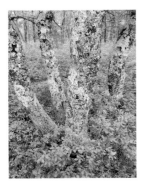

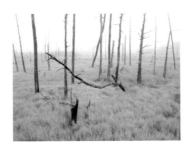

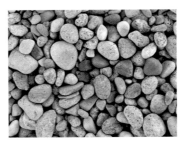

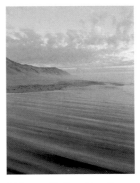

Mashpee;
Red Oak; *Quercus rubra*
p. 47
This was a difficult shot. With my 45mm lens (equivalent to a 28mm in 35), I tried to maximize hyperfocal so the foreground and the background would be sharp. The first tree leaned forward and threw off the minimum hyperfocal distance. I couldn't move back because nearby branches from other trees came into the compostion. It took tedious adjustments of the tripod and my ball head to make this shot.
2 seconds at f11
41 36.080 - 70 26.596

Swan Pond River, Dennis;
p. 49
I watched a low ground fog move between the trees. There were dew-covered spider webs everywhere and, at one point, a praying mantis climbed up my arm.
2 seconds at f22
41 40.329 - 70 08.437

East Sandwich Beach, Sandwich;
p. 51
This frame came with little effort. At the time, I didn't have a distinct impression of what the shot was going to be. As soon as I arrived, I bolted up and over the banking which seemed to lead directly to this bed of pebbles.
1/2 second at f22
41 45.240 - 70 06.821

Cahoon Hollow Beach, Wellfleet;
p. 53
Many times I ended up in the water to photograph the currents of the Atlantic. With each incoming wave, my tripod and I sank a little lower in the sand. Keeping my camera dry was an ongoing task for the summer.
1/4 second at f22
41 56.976 - 69 59.190

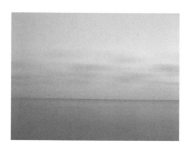

Great Island, Wellfleet;
p. 55
I went to Great Island many times throughout the summer. I walked along the shores at sunrise and sunset and spent hours sitting on the sand, staring out to sea. This photograph expresses those experiences.
8 seconds at f22
41 56.076 - 70 04.418

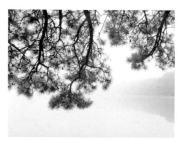

Gull Pond, Wellfleet;
Pitch Pine; *Pinus rigida*
p. 57
There were two occasions before sunrise when Mike Goshorn and I ran into the same group of people who happened to share our location. Our new friends made it clear we needed to follow a "magical trail" before the fog lifted. Soon I came across a pitch pine tree overhanging this pond.
4 seconds at f22
41 57.553 - 70 00.410

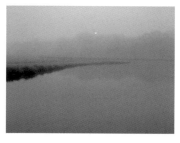

Fresh Pond, Dennis;
p. 59
It was a little scary walking in waders in this pond because I couldn't see what was below me. I tried to use my tripod as a walking stick and ended up in this little cove and noticed these grasses sporadically springing from the water.
1/2 second at f22
41 40.578 - 70 09.026

Swan Pond River, Dennis;
p. 61
Wading about five feet from the bank of the marsh, I sank to my chest in mud. Because I nearly lost my camera, I decided to stay on the spongy grasses of the marsh.
1 minute at f22
41 40.265 - 70 08.548

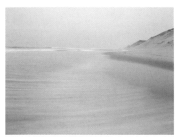

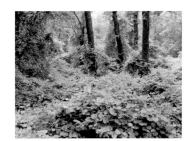

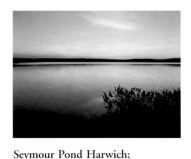

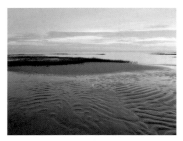

Longnook Beach, Truro;
p. 63
Kristin Nason and Chris Sullivan invited me to this wonderful place. Their persistance became part of the photograph.
1 second at f22
42 01.492 - 70 02.433

Nickerson State Park, Brewster;
Round-leaved Greenbrier;
Smilax rotundifolia
p. 65
Originally I wanted to get closer to the four trees in the back corner and still have the round-leaved greenbrier in the foreground. I became entangled in their incredible vine structures and could not for the life of me get out there.
1/2 second at f22
41 46.081 - 70 01.0315

Seymour Pond Harwich;
p. 67
One evening Chris Sullivan, Aaron Klein, and I piled in an ice cream truck and drove down Rt. 124. Heading for the outdoor movies, we passed Hinckleys Pond and Seymour Pond shortly after the sun had gone down. The silhouettes with the reflection of the sky in the water were amazing. Knowing my camera was hibernating in the closet, Chris somehow managed to say, "Don't you wish you had your camera, Brian?" I came back the next day.
1 second at f22
41 43.381 - 70 05.159

Paines Creek Beach, Brewster;
p. 69
For an entire week, I shot in olive green waders. At 4:00 a.m., after several snooze sessions, I awkwardly put on my waders one more time and drove to this beach to watch the sunrise.
1 second at f22

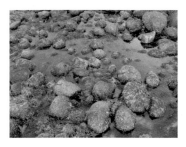

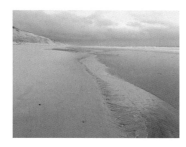

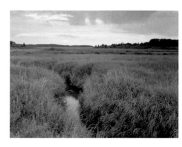

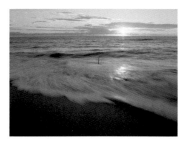

Sagamore Beach, Bourne;
p. 71
The tide was out, the sun was rising, and I was sprinting to these rocks I found the day before. Originally I faced the other direction until a green crab caught my eye. I followed it to these seaweed-covered rocks.
2 seconds at f22
41 48.349 - 70 31.987

Marconi Beach, Wellfleet;
p. 73
It was extremely windy this day. Mike Goshorn and I wandered about the beach to find something to photograph. Although two people can photograph in the same conditions, it is rare that they will interpret the experience in the same way. Even so, after I took this scene, I dragged my foot in the sand and wrote, "Already been done," anticipating his arrival soon after.
1 second at f22
41 53.643 - 69 57.746

Brewster;
p. 75
Driving on Rt. 6A, I passed a bridge before Paines Creek Road and impulsively stopped. I walked in green waders to photograph this grass-filled marsh. Certainly there are times when we don't listen to ourselves. But it's the times we do that makes us wonder why we don't more often.
8 seconds at f22, 3-stop Grad ND
41 45.257 - 70 06.821

Cahoon Hollow Beach, Wellfleet;
p. 77
I took three frames of this composition and there are no two the same. Although I released the shutter just as a wave was going to break, this was the only frame related to the incoming tide.
1/2 second at f22
41 56.717 - 69 59.016

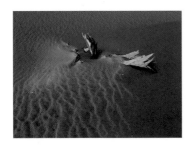

Sandy Neck Beach, Barnstable;
p. 79
I conquered one dune only to find another taking its place. At the base of one, I found a piece of driftwood seized by the sand. The orange glow on the driftwood with the blue shadows in the ripples caught my interest.
1/15 second at f22
41 44.222 - 70 22.265

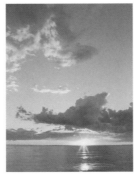

Old Silver Beach,
Falmouth;
p. 81
Sunset illuminated these enormous clouds. Without any hesitation I plunged into the water, fully clothed, and composed this shot only seconds before the light changed.
1/2 second at f22
41 37.450 - 70 38.426

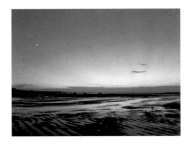

Breakwater Beach, Brewster;
p. 83
This was the last photograph of the summer. Looking at it, I remember three months on the cape—and all the little details in between.
1 second at f22
41 46.132 - 70 05.269

Index